Prick Secret

Hilarious Swear Word Coloring Book

For Fun & Stress Releasing

Charles C. Golden

Copyright © 2017 by Charles C. Golden

All rights reserved worldwide. No part of this publication may be reproduced or distributed in any form or by any means, mechanical, electronic or stored in a retrieval or database system, without written permission from the copyright holder.

Happy Coloring!

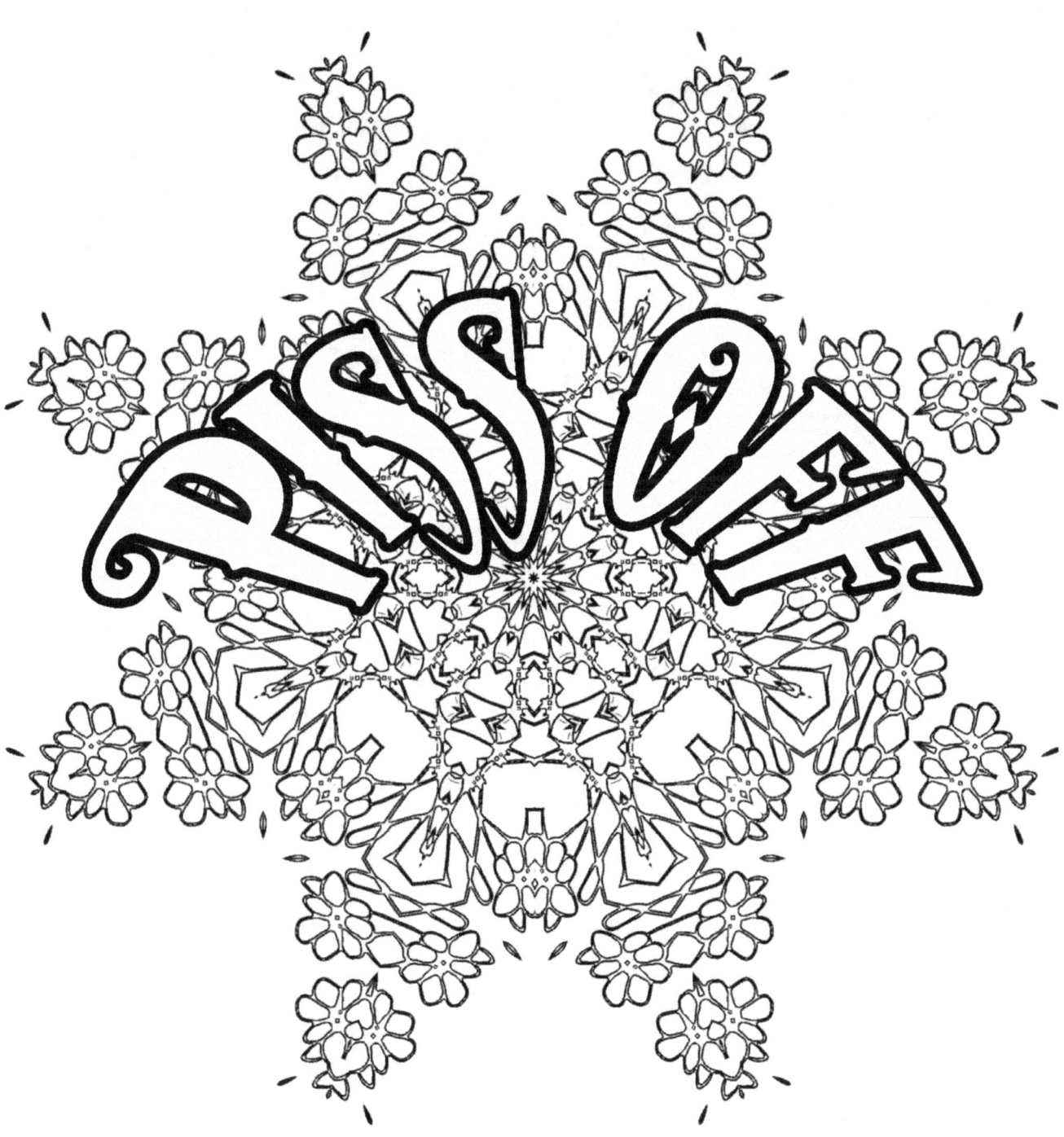

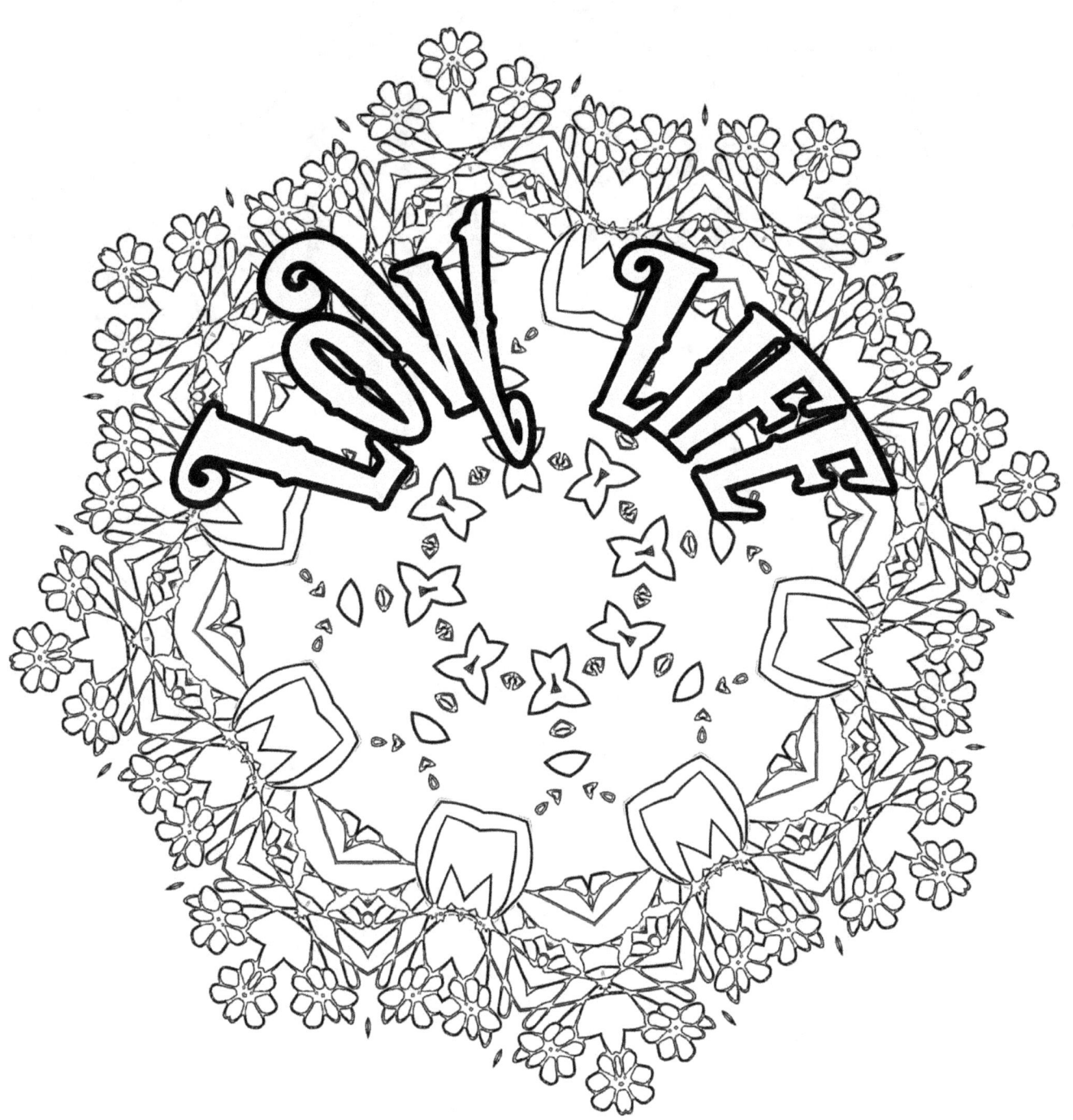

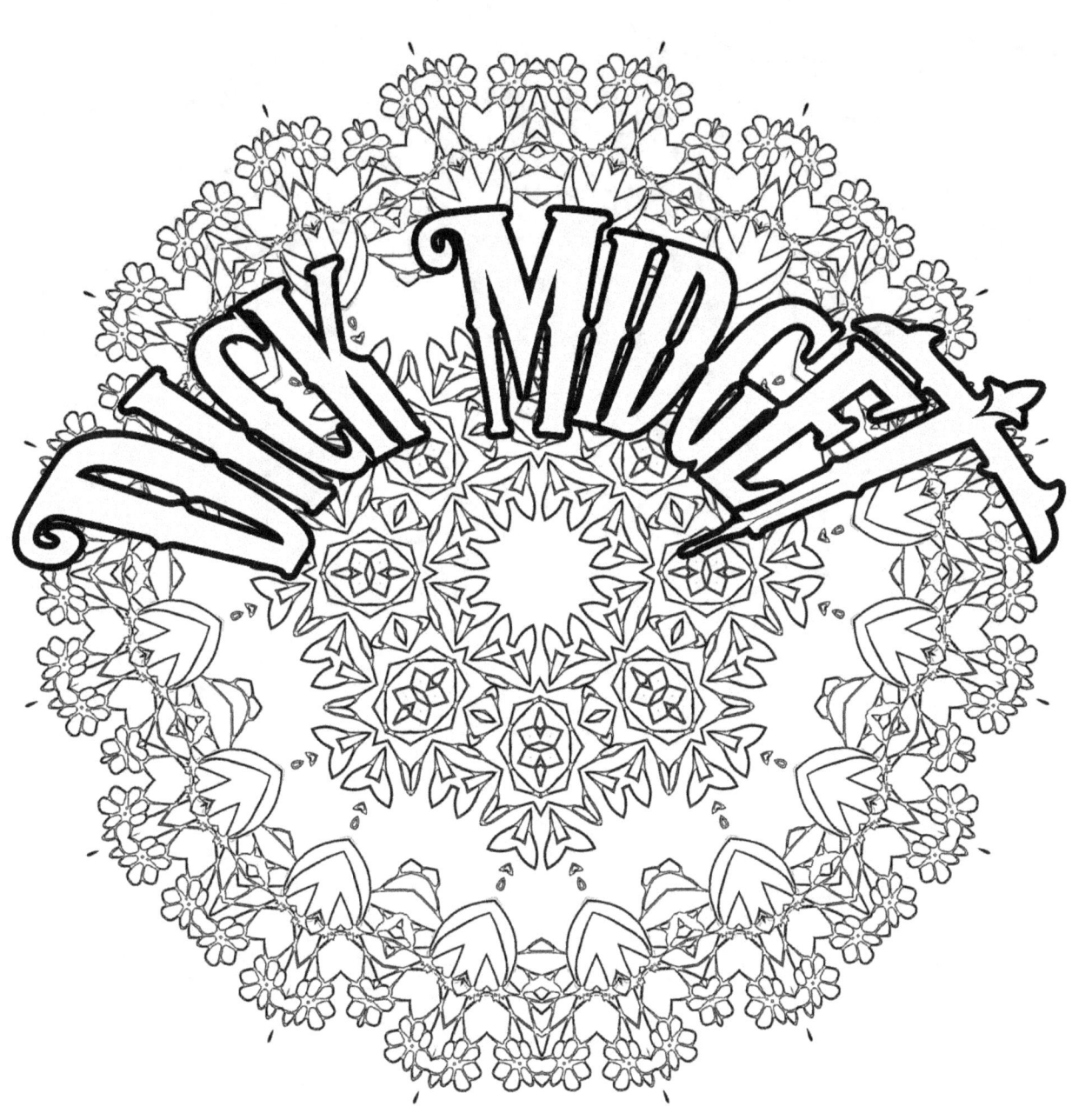

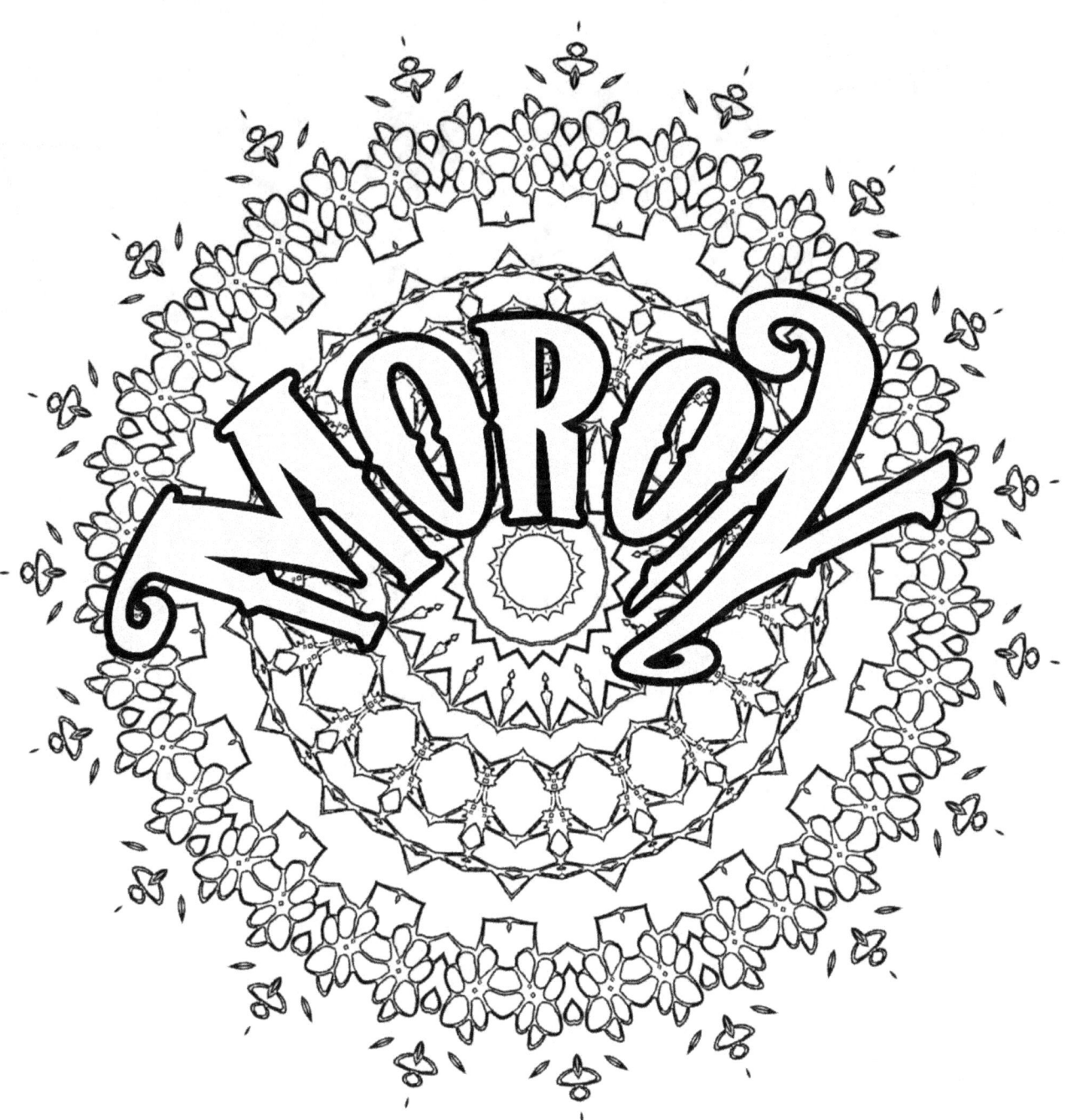

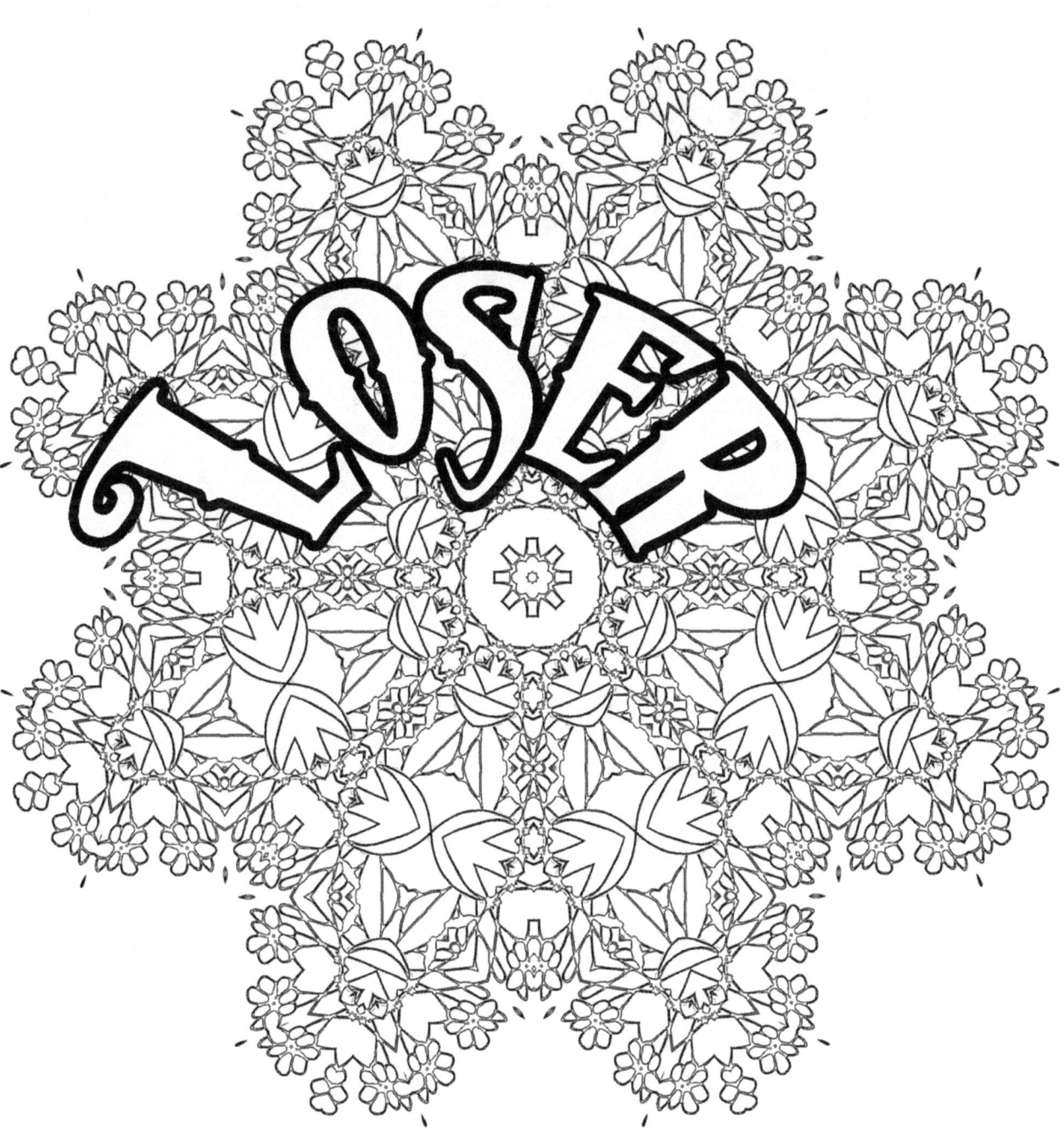

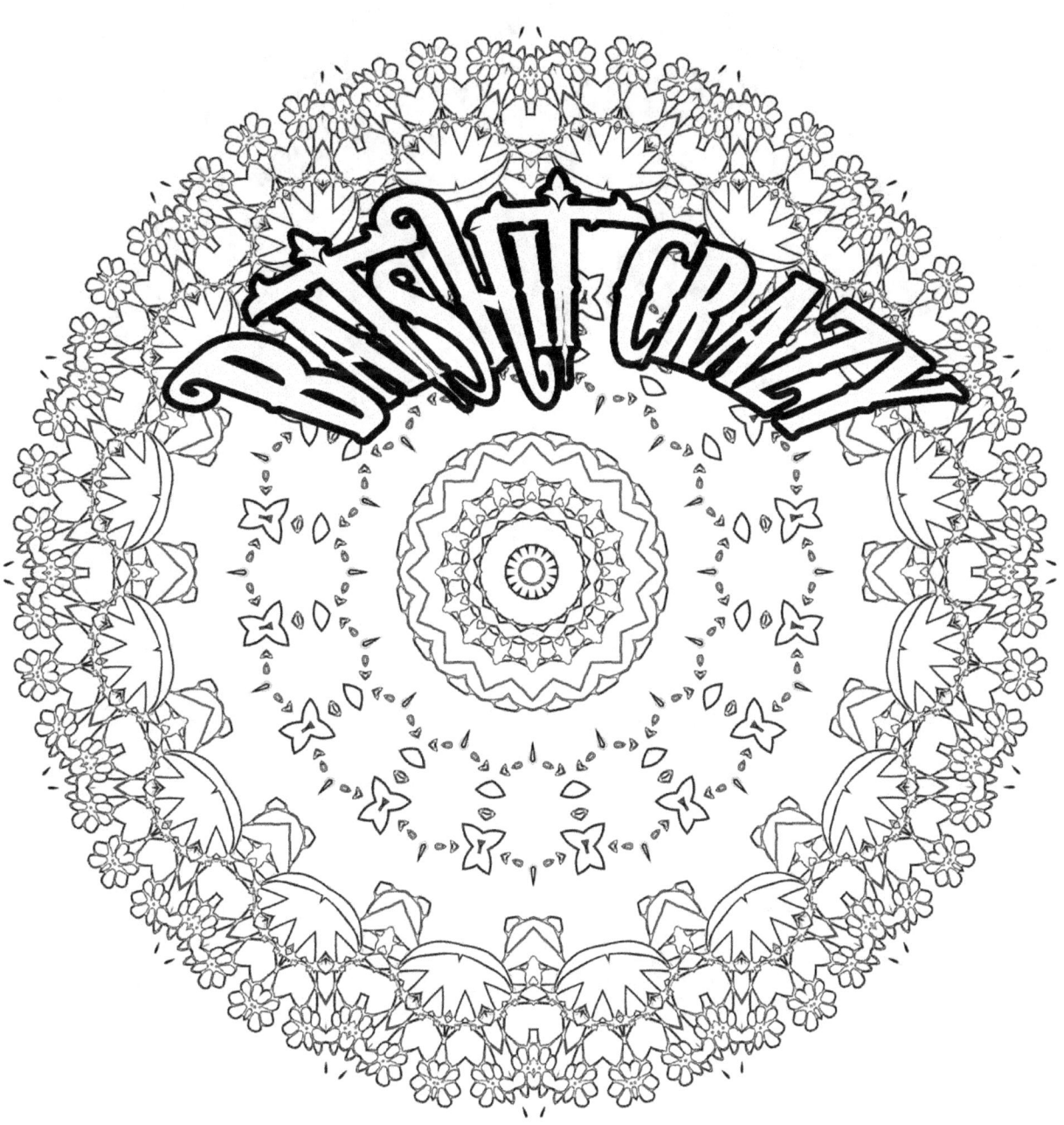

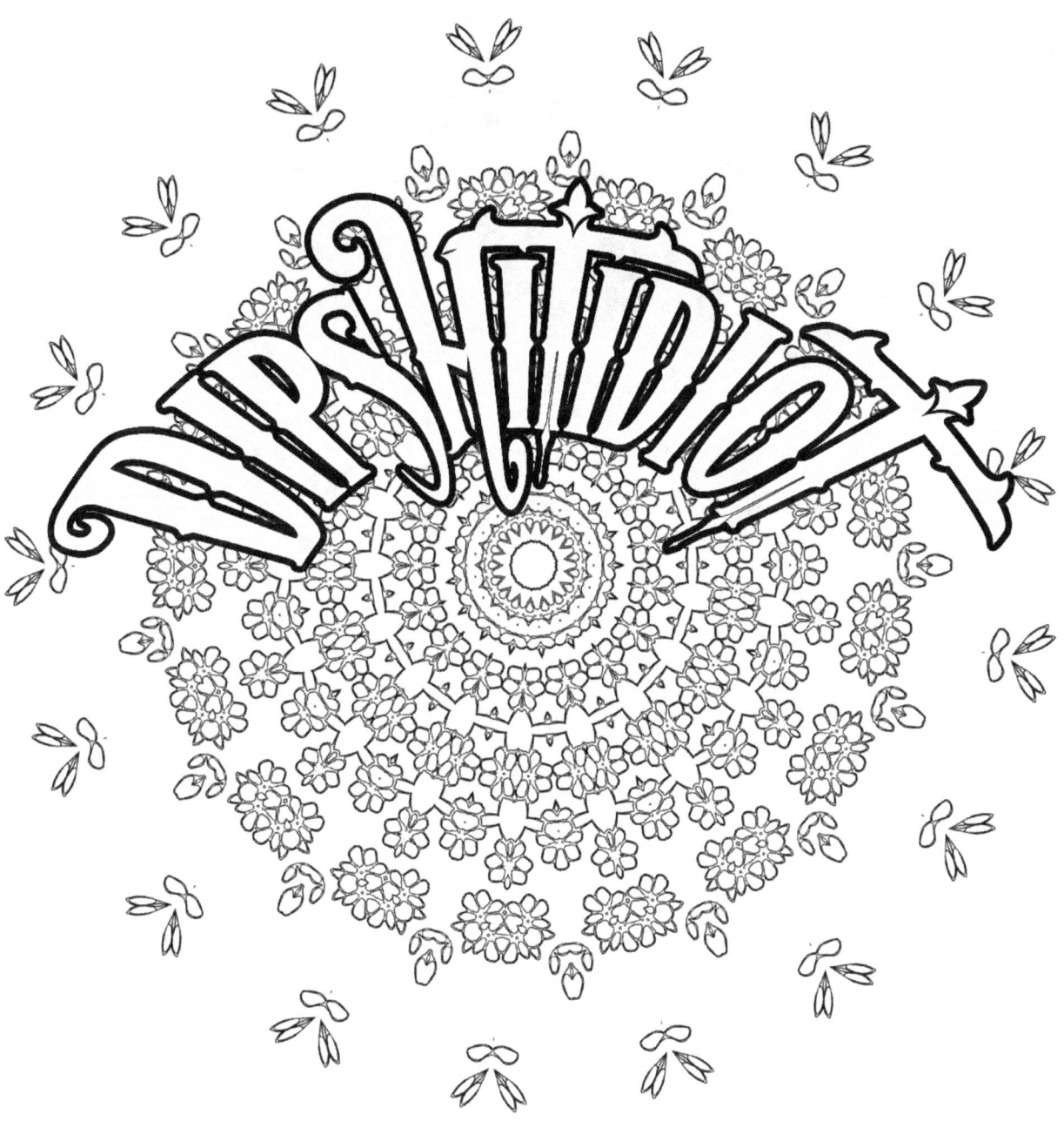

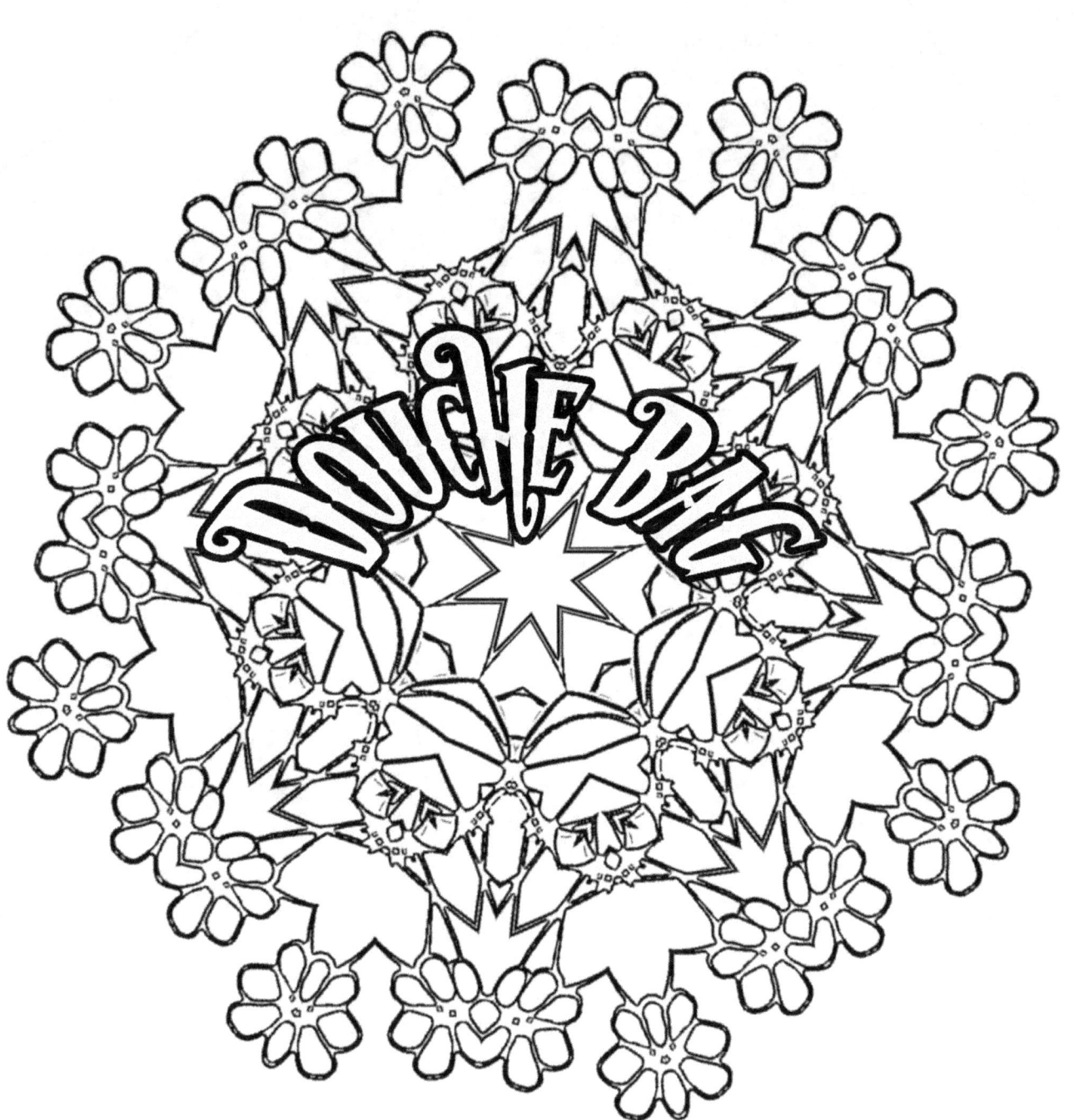

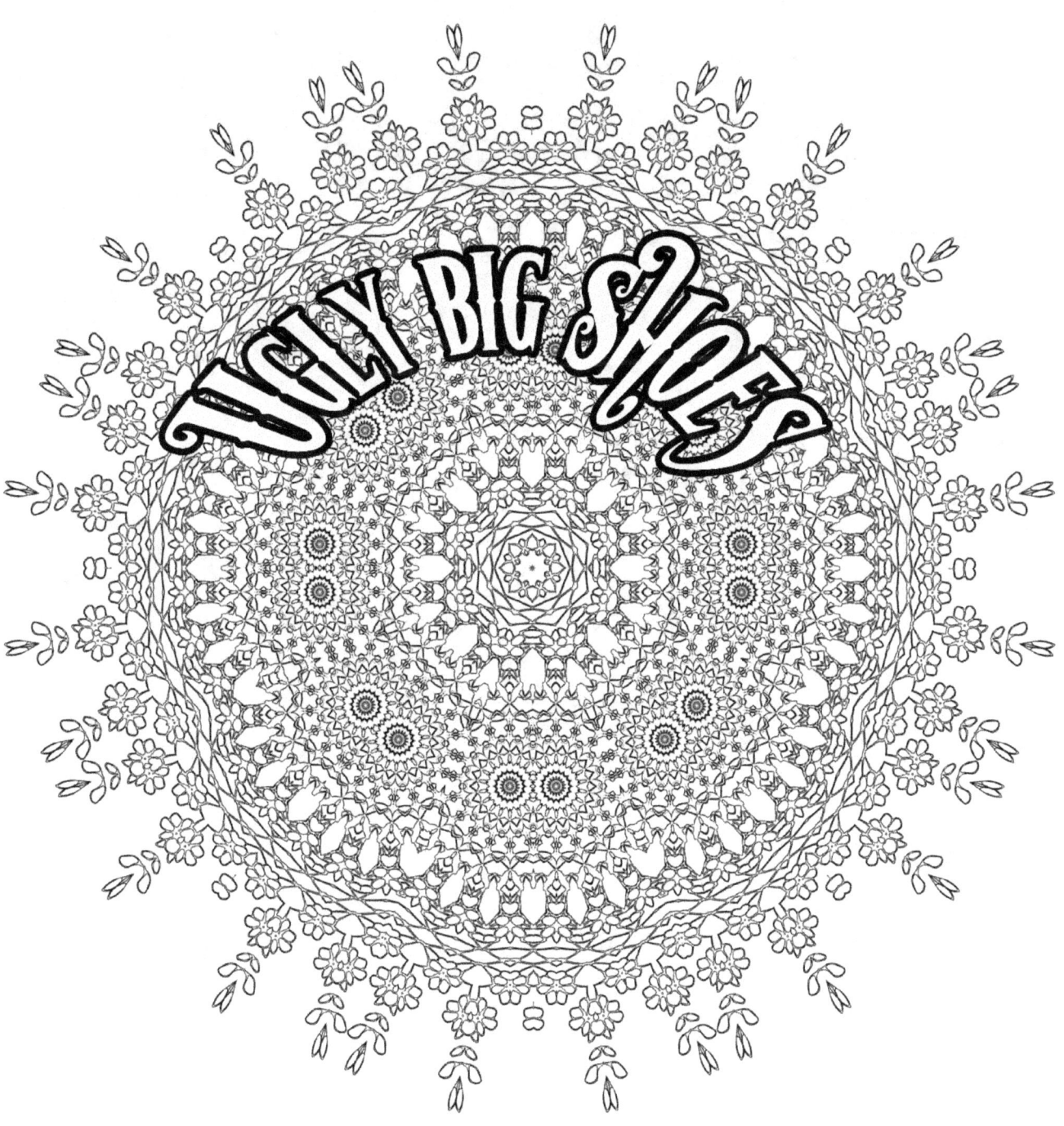

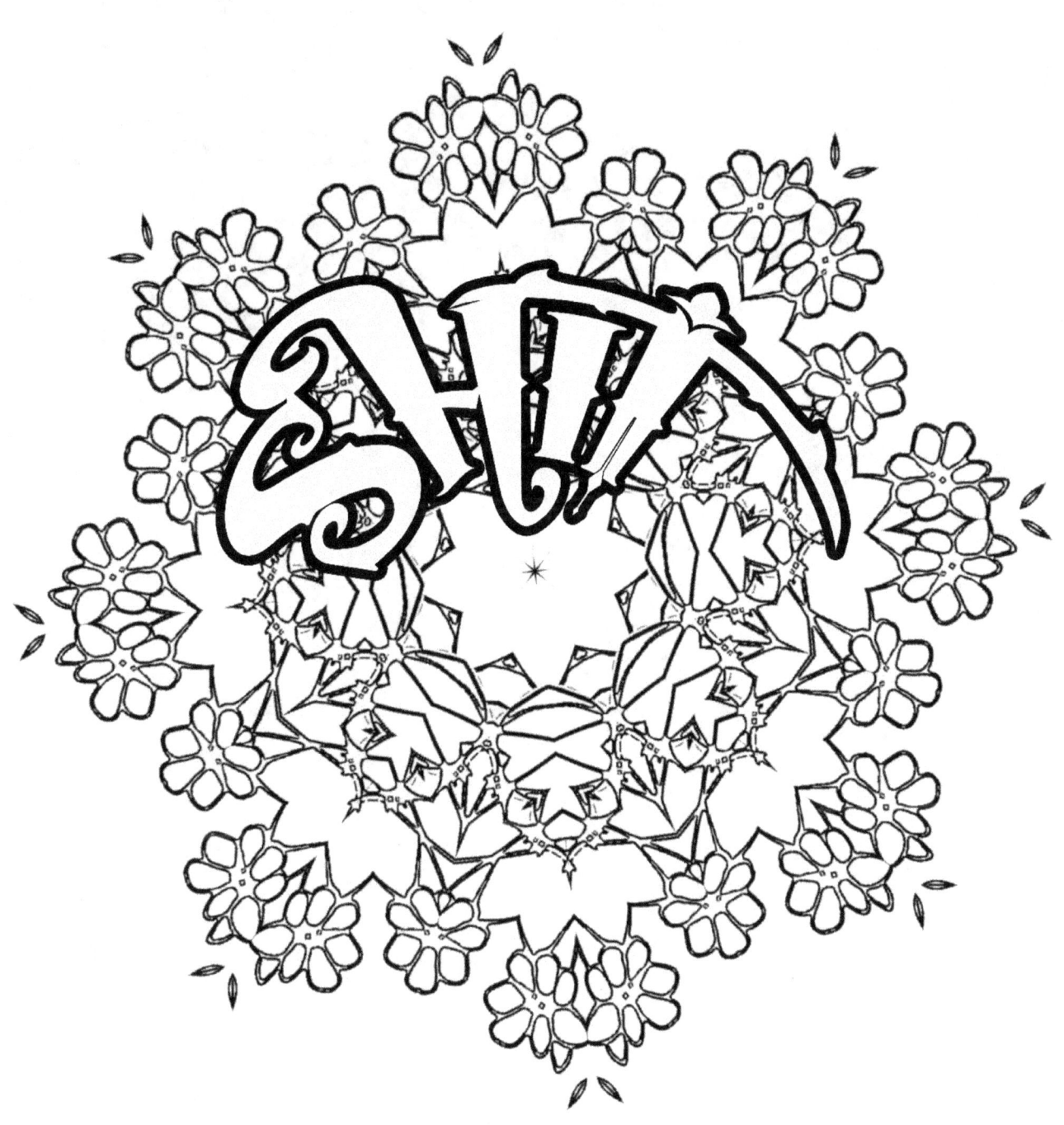

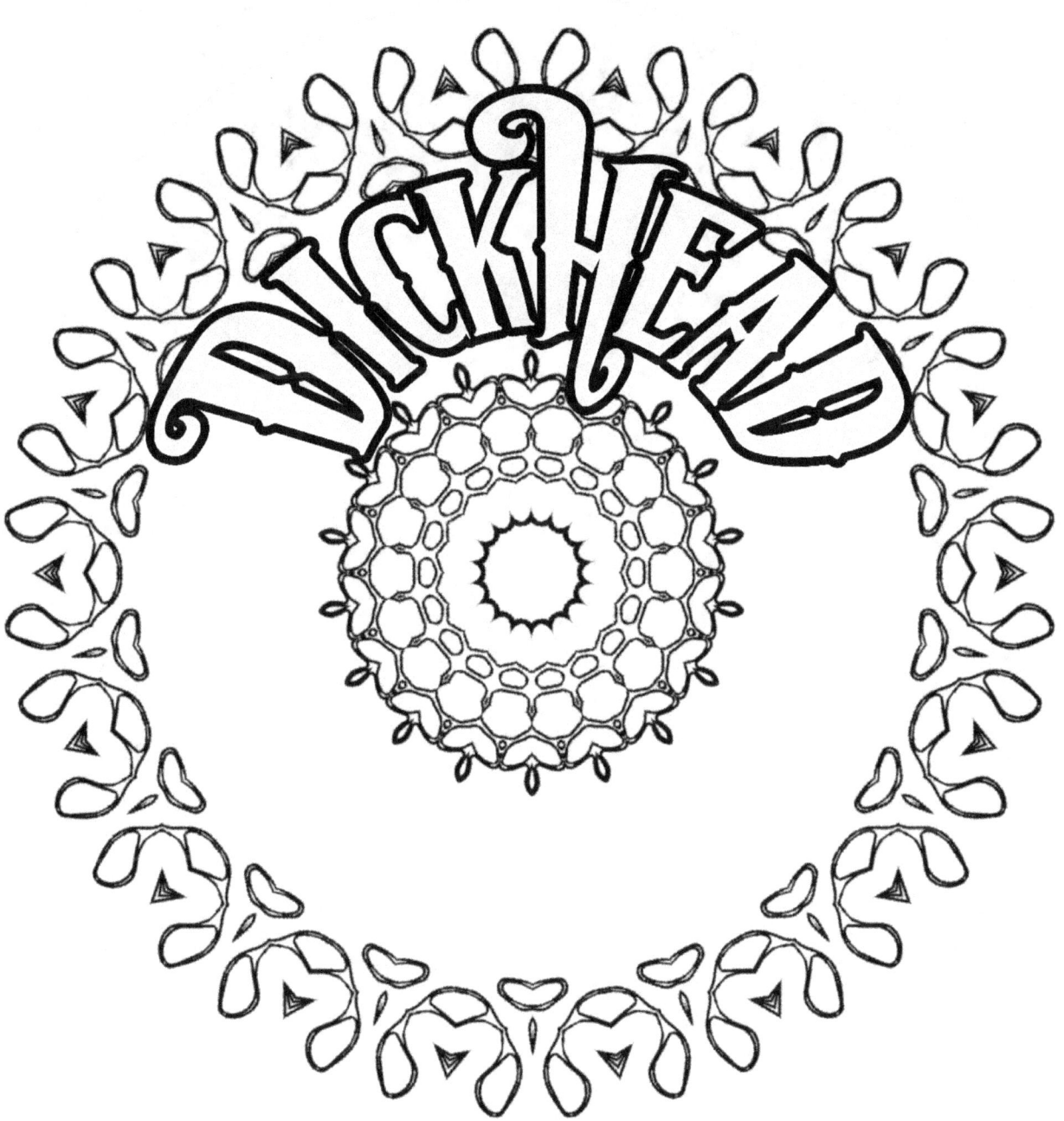

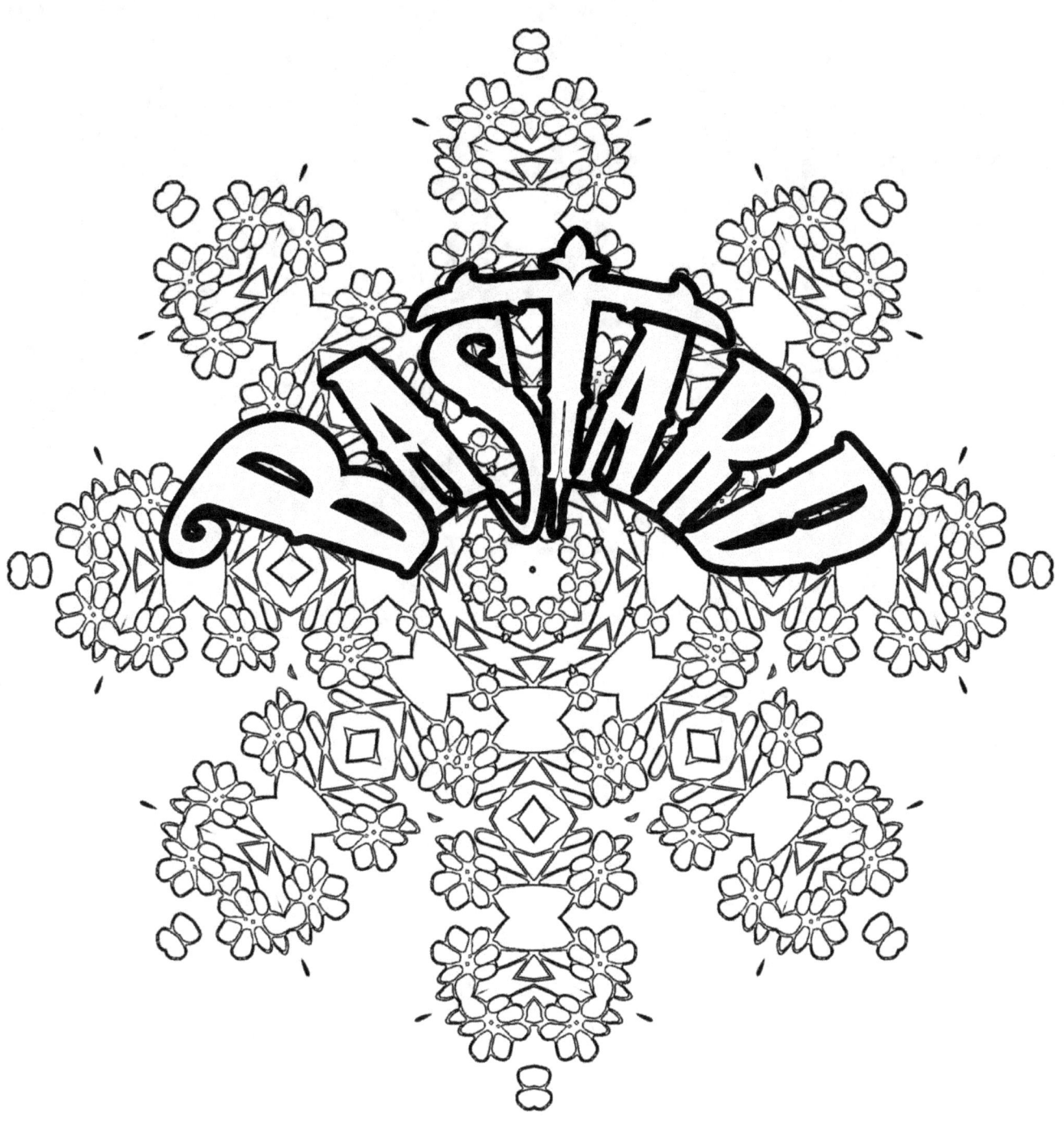

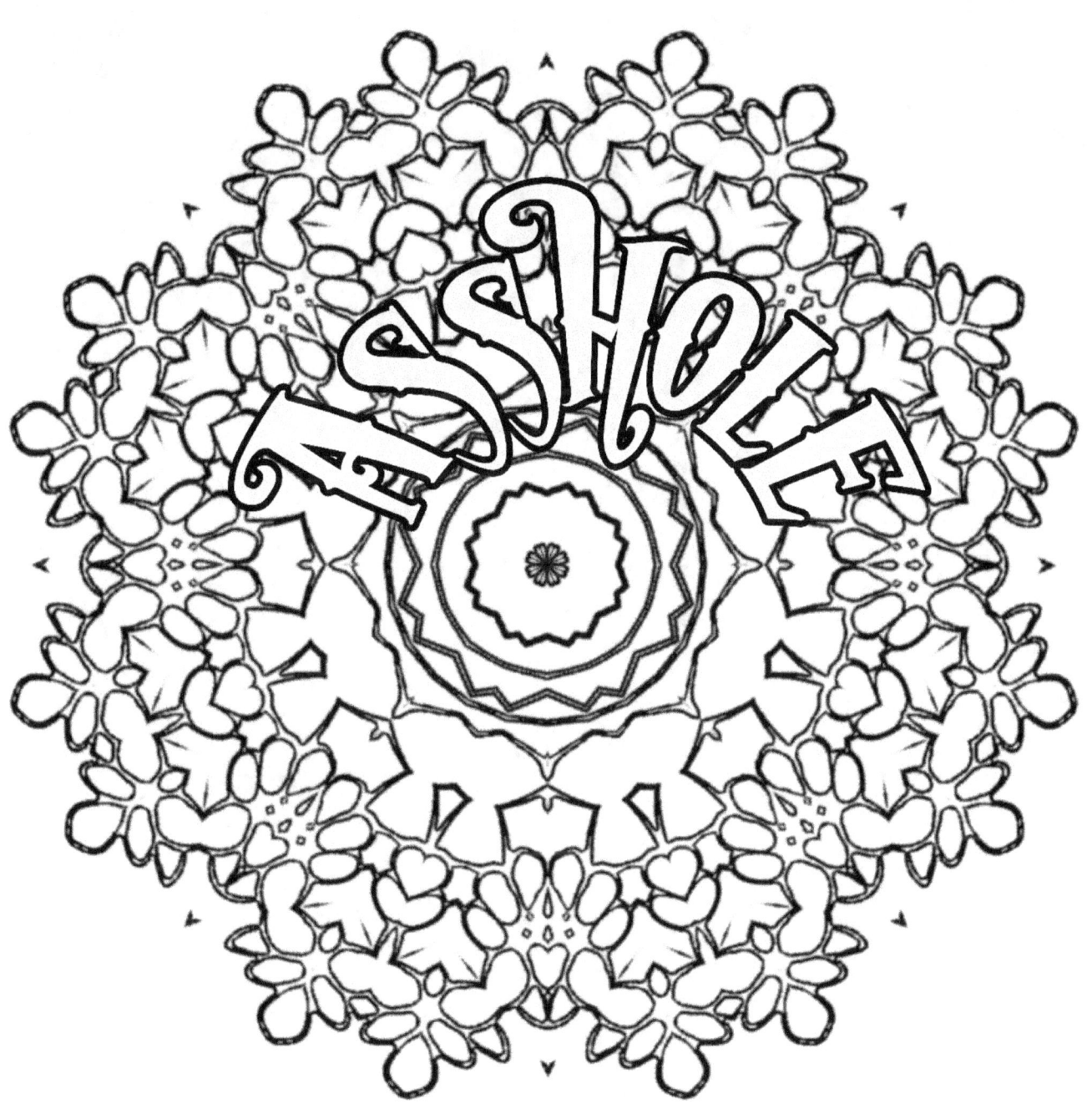

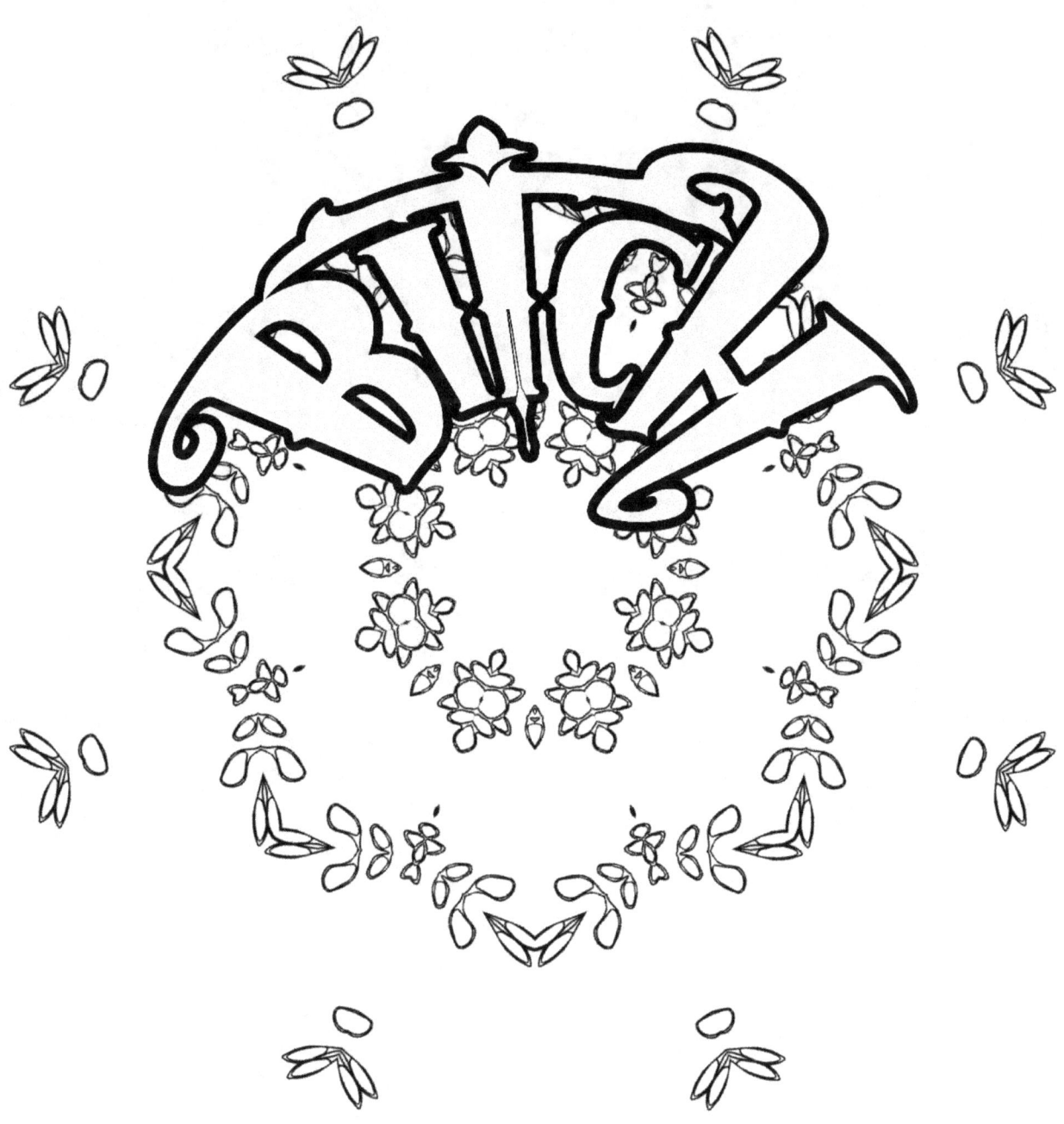

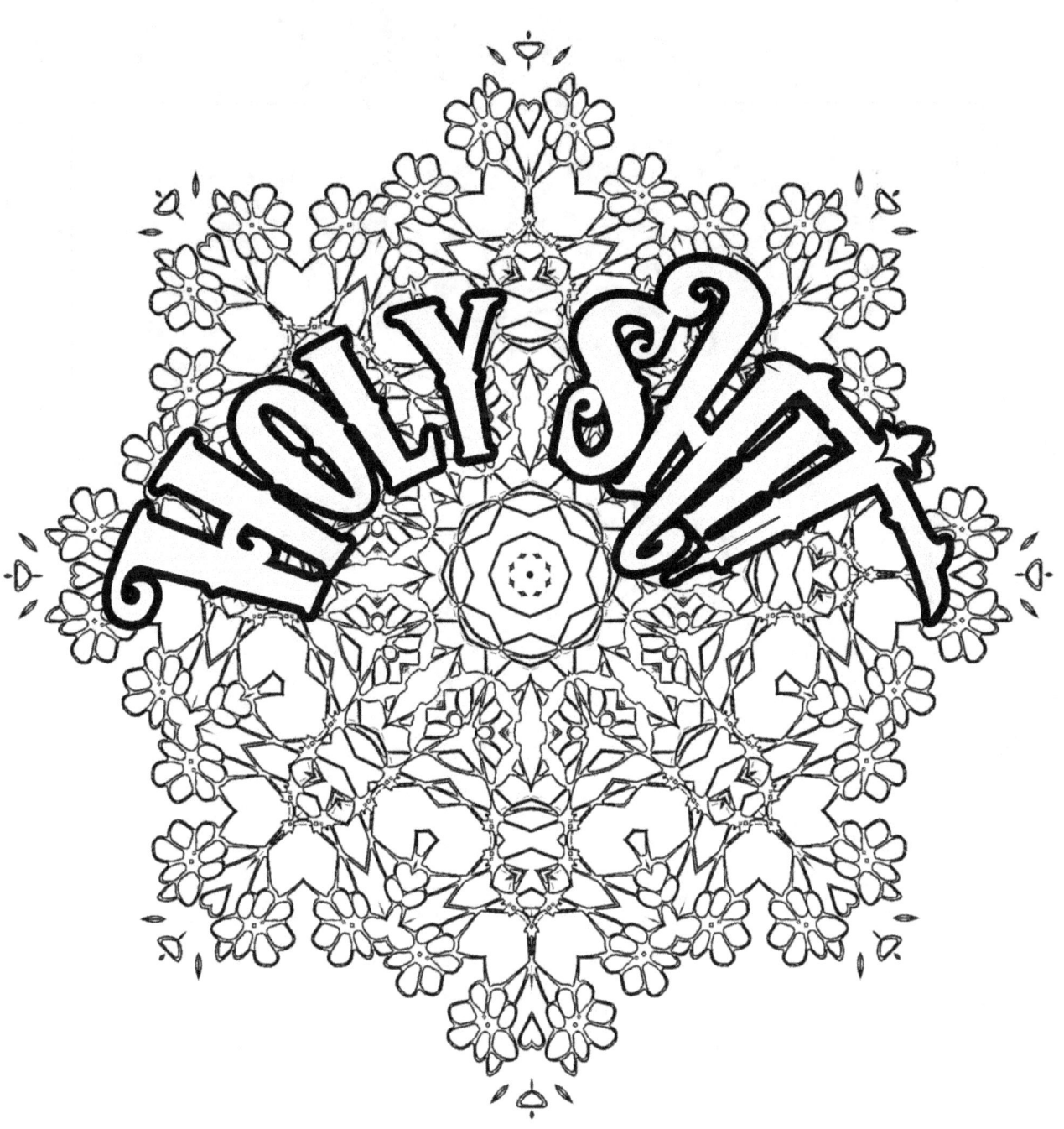

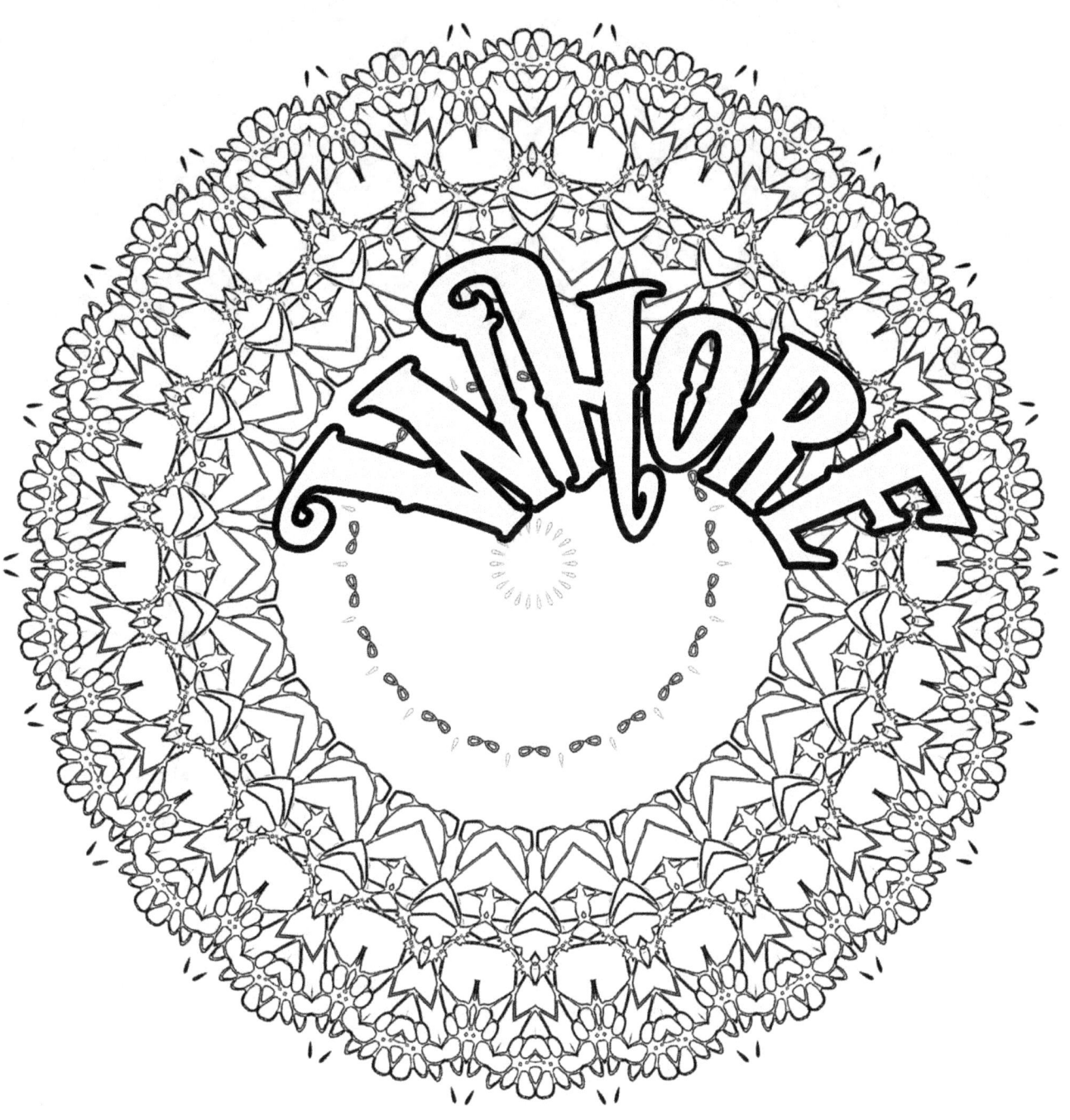

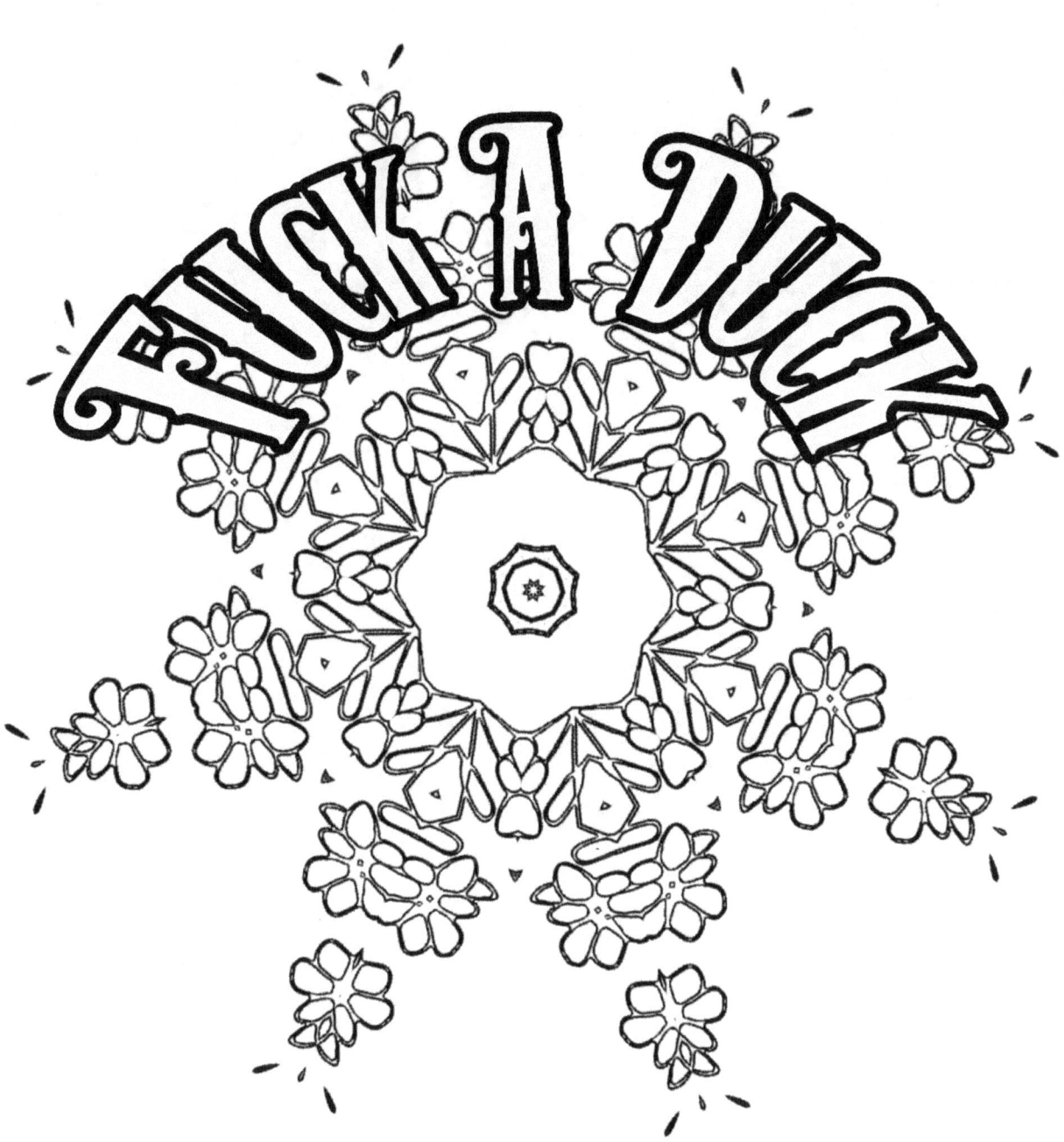

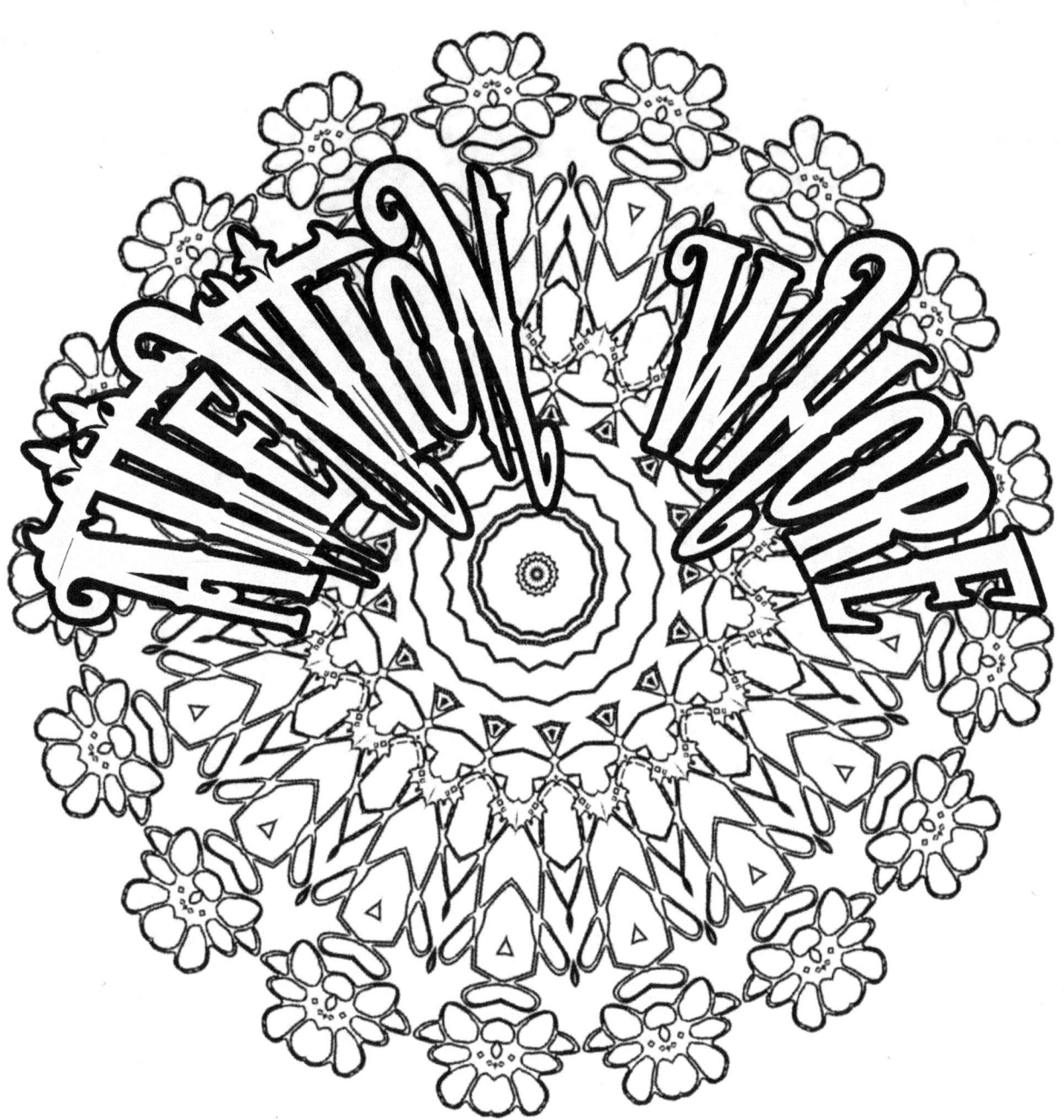

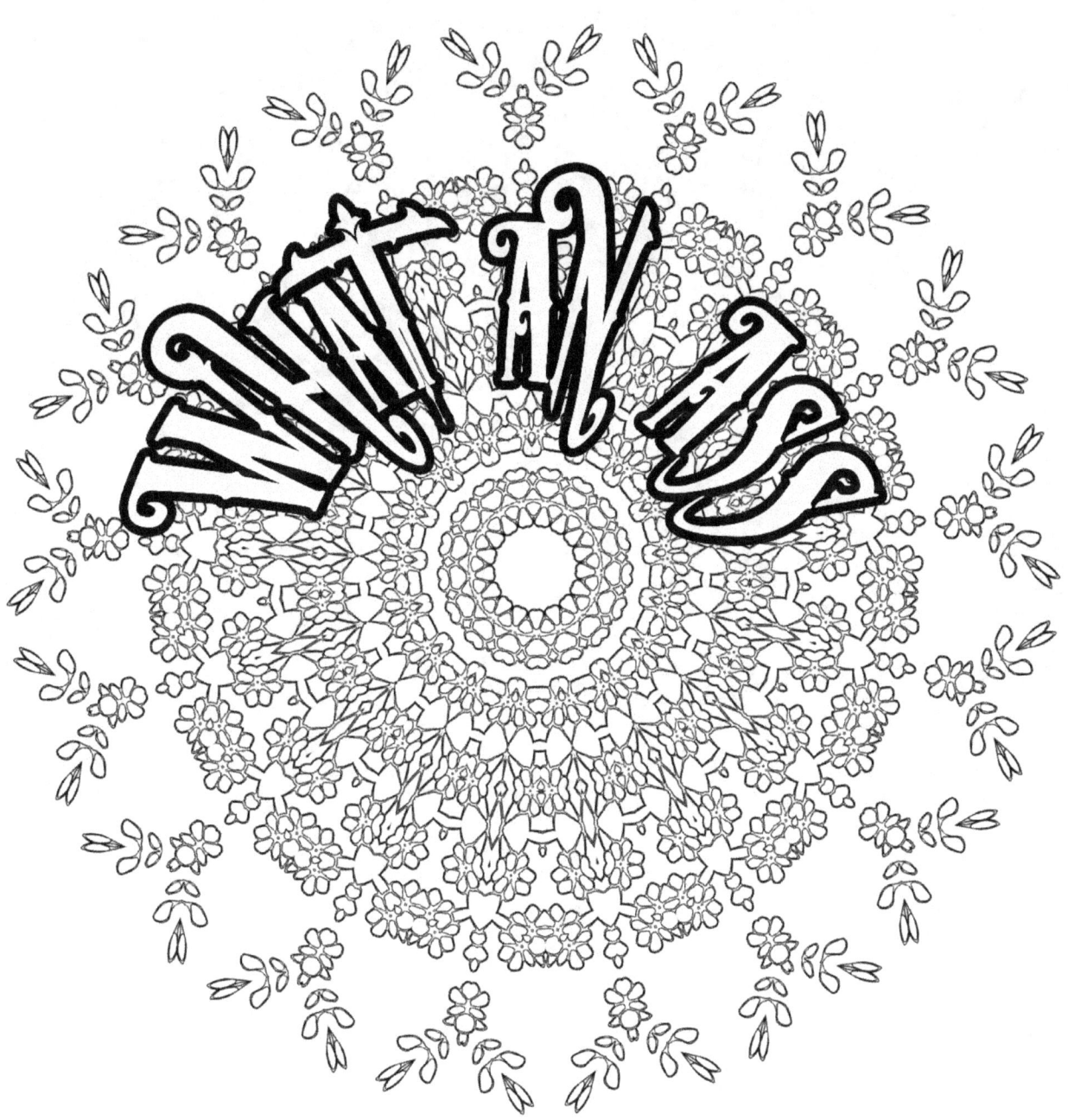

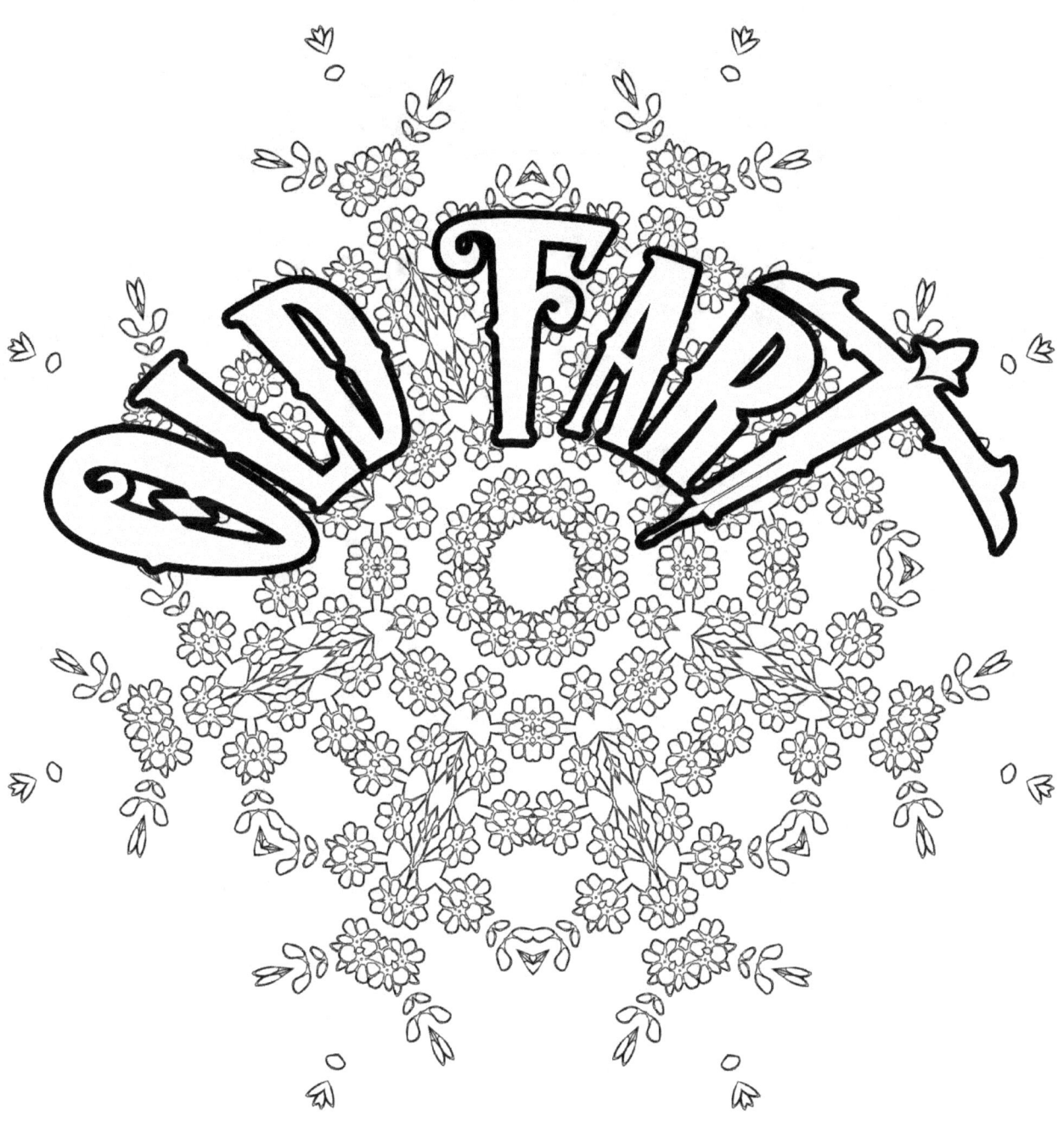

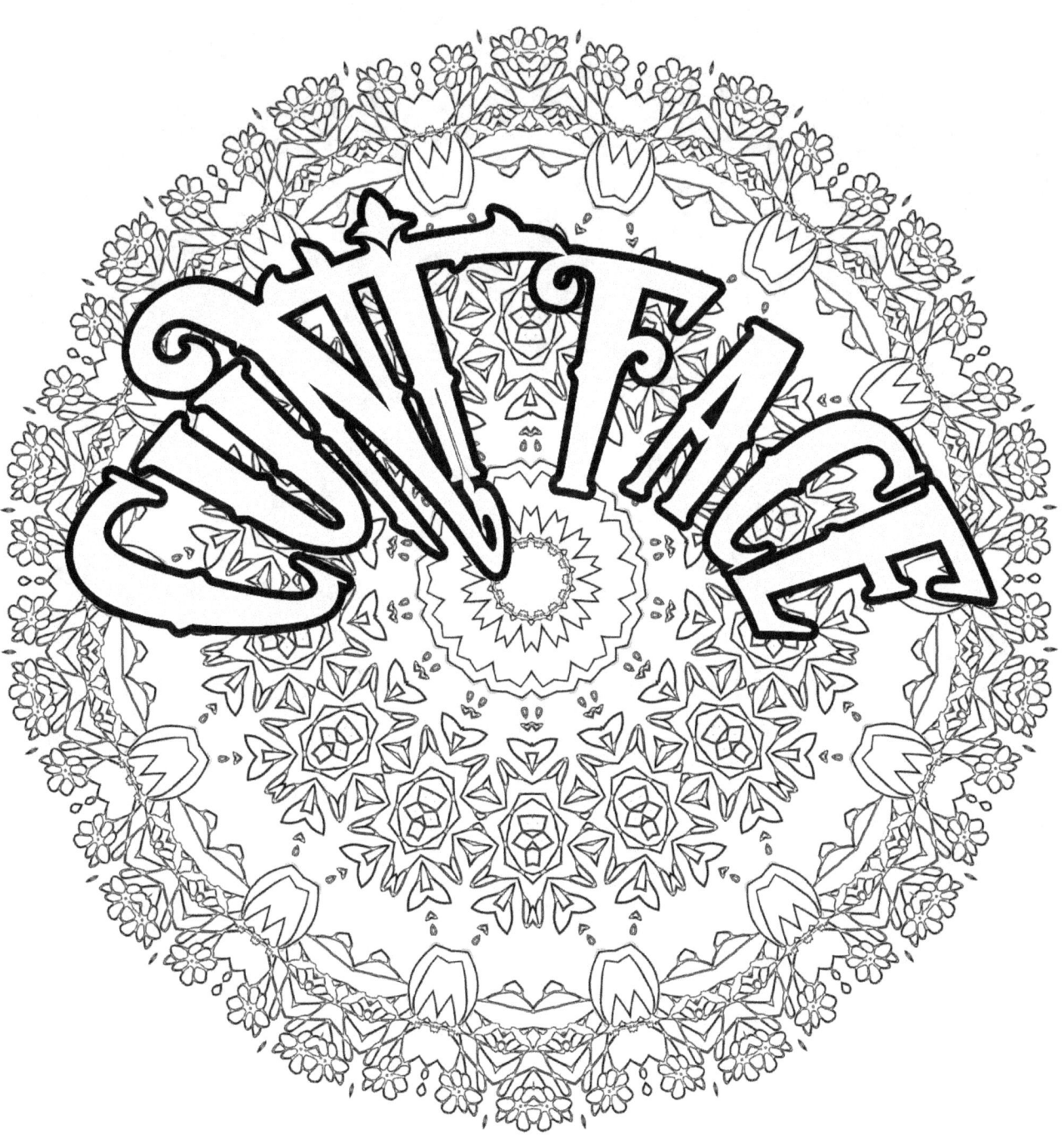